Flowers

IMAGES FROM HAWAI'I'S GARDENS

David and Sue Boynton

Mutual Publishing

ISBN 1-56647-768-9
Library of Congress Catalog Card Number:
2005938951

First Printing, March 2006
1 2 3 4 5 6 7 8 9

Much of the information for captions in this book came from the excellent new reference book, *A Tropical Garden Flora* by George W. Staples and Derral R. Herbst, published by Bishop Museum Press in 2005.

Mutual Publishing, LLC
1215 Center Street, Suite 210
Honolulu, Hawai'i 96816
Ph: 808-732-1709 / Fax: 808-734-4094
Email: mutual@mutualpublishing.com
www.mutualpublishing.com

Printed in China

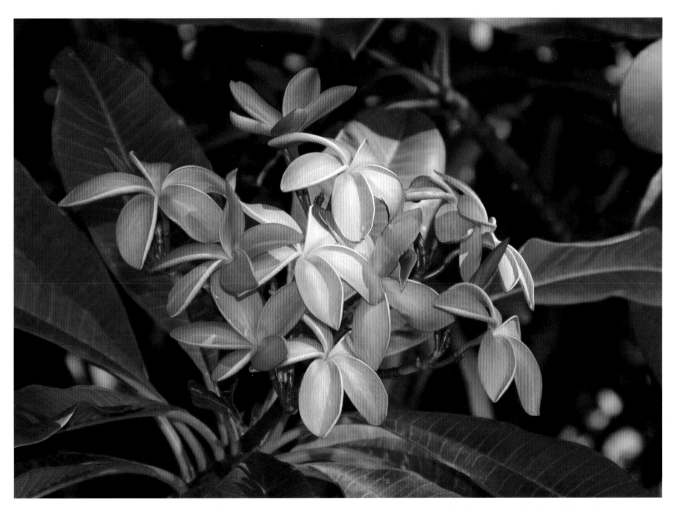

Fragrant plumeria blossoms are popular lei flowers in Hawai'i, with dozens of colorful varieties.

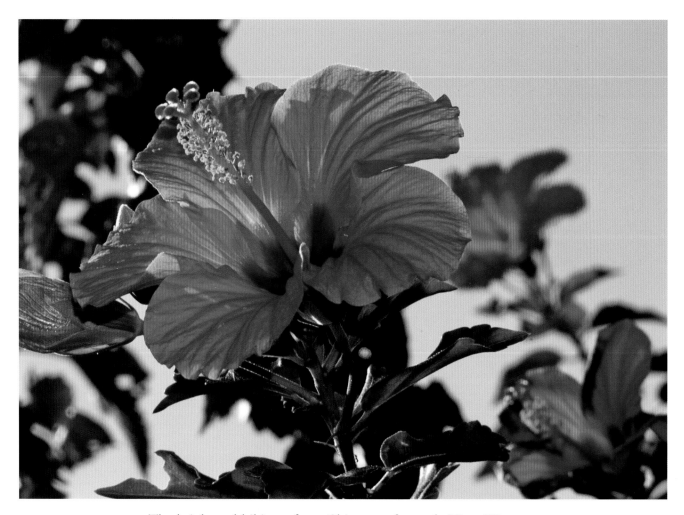

The bright red hibiscus from China was formerly Hawai'i's state
flower until replaced by a yellow-flowered native species.

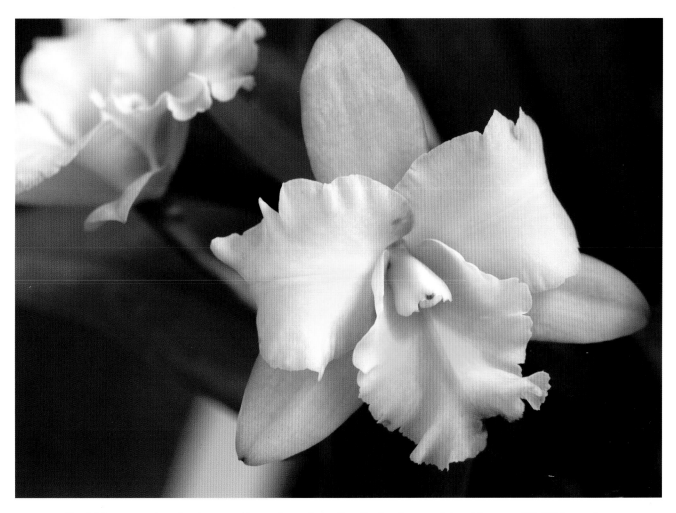

Orchids comprise the largest flowering plant family in the world, with over 20,000 species.

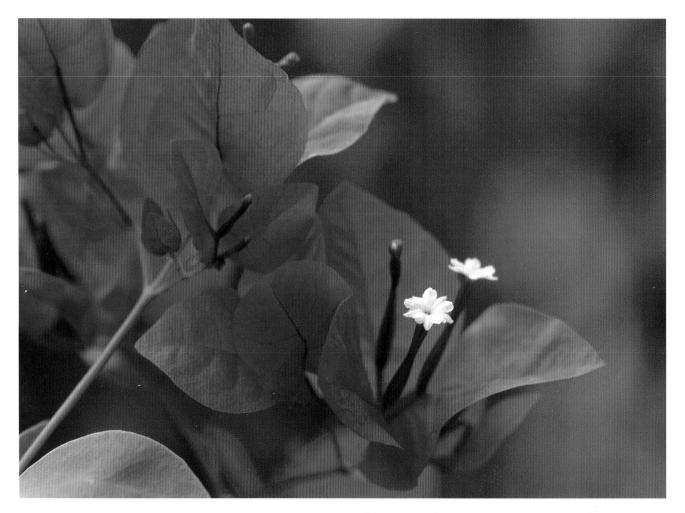

Small white flowers nestle amongst the colorful bracts of bougainvillea, a native of South America that thrives in arid environments.

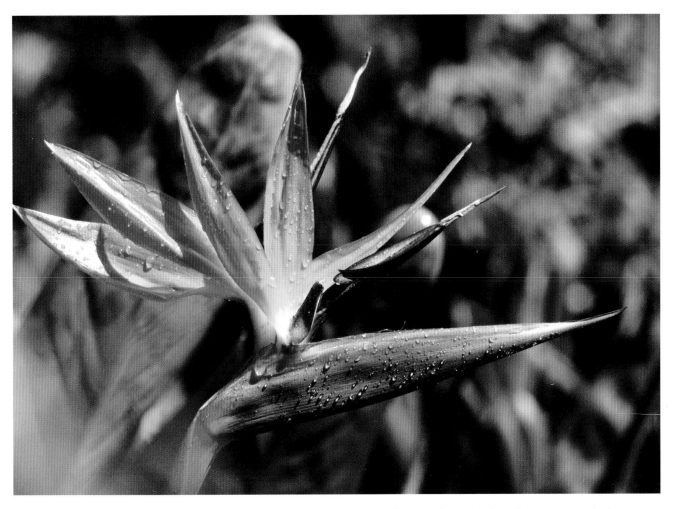

Originally from South Africa, the bird-of-paradise produces a long-lasting flower, a symbol of tropical gardens that may be pollinated by birds.

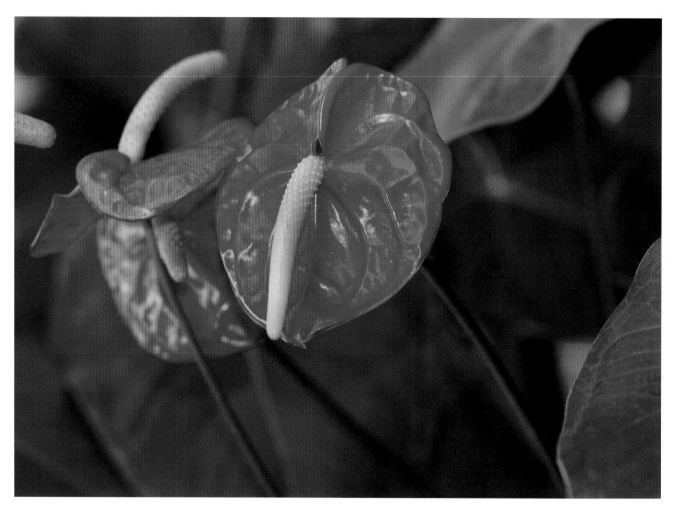

A relative of taro, anthurium is a genus of over 700 species native to tropical America, where they often grow attached to rain forest trees.

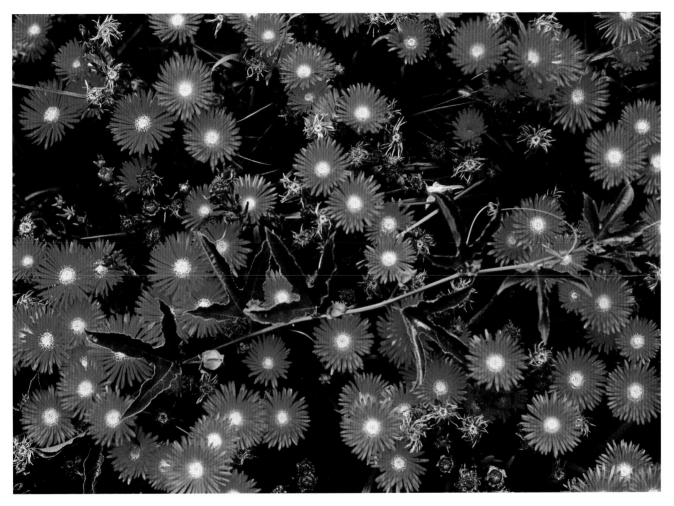

'Ākulikuli is a hardy, succulent groundcover that flowers profusely in cool
conditions above 2,000' elevation in the Islands.

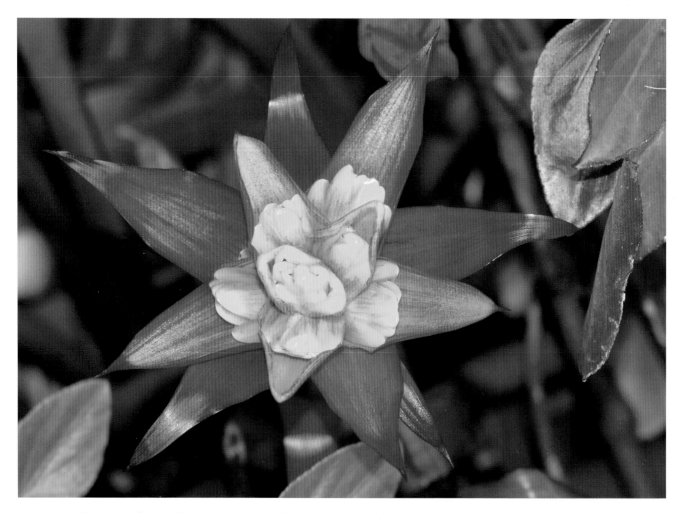

Popular for landscaping and cut flowers, colorful bromeliads are hardy tropical plants adapted to a wide range of rainfall conditions.

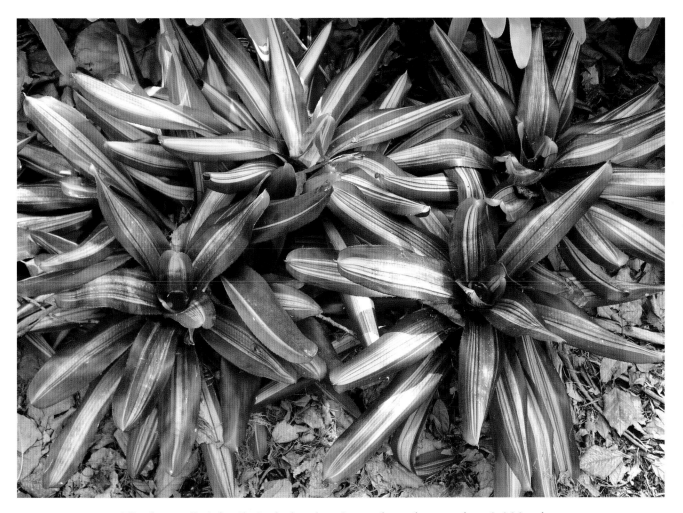

The bromeliad family includes the pineapple and more than 2,000 other species of tropical American plants with colorful flowers and foliage.

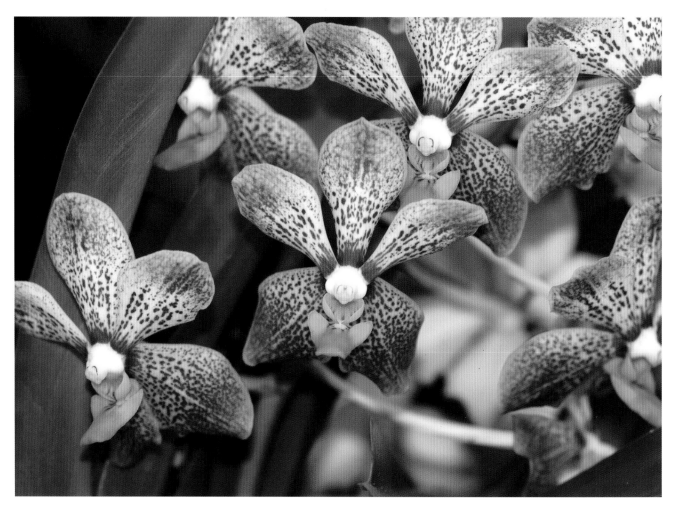

The intricate design of orchid flowers is an attraction to insects and other pollinators.

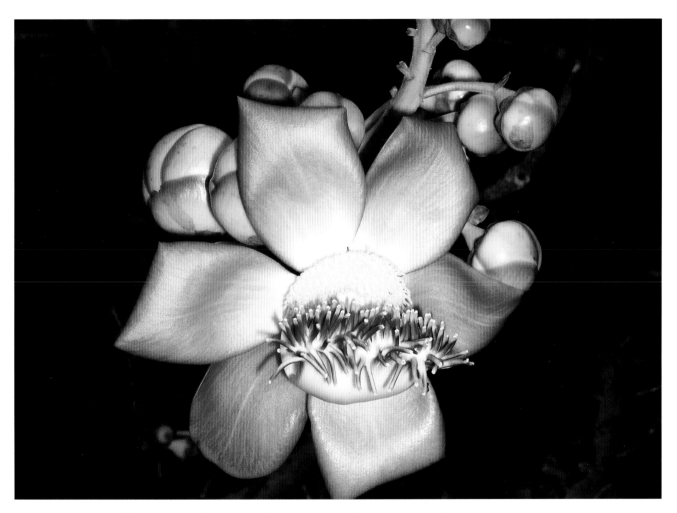

The unique flowers of the South American cannonball tree develop into
a foul-smelling fruit up to eight inches in diameter.

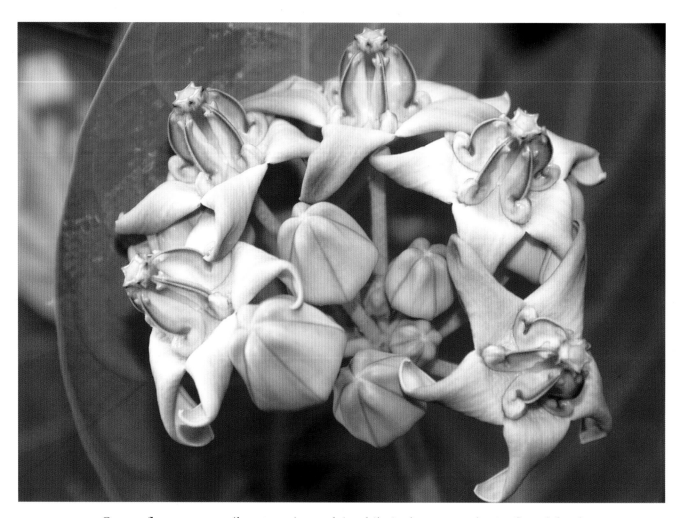

Crown flowers are easily strung into a lei; while its leaves are the preferred food for caterpillars of monarch butterflies, the plant is poisonous to people.

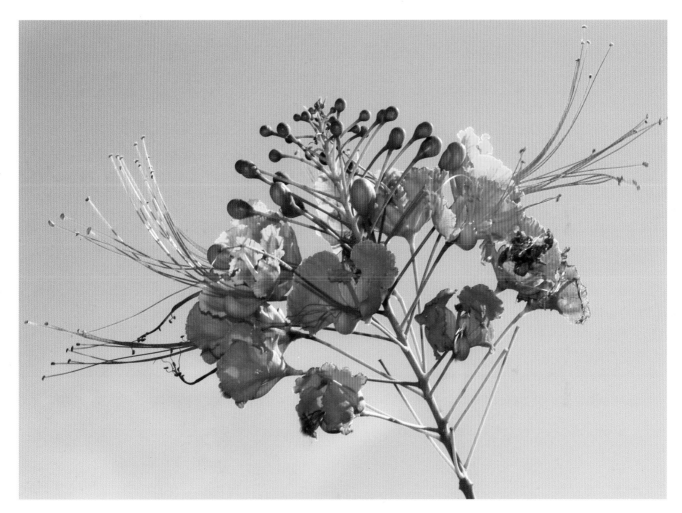

Also known as dwarf poinciana, the flowers of ʻohai aliʻi are popular for lei-making.

Poinsettia, whose bright red blooms are a symbol of Christmas, was cultivated by
the Aztecs long before being "discovered" by Europeans.

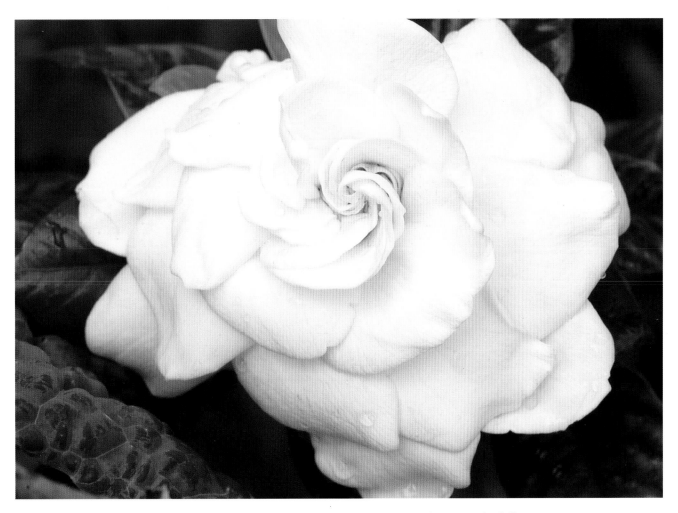

A member of the coffee family, the gardenia has wonderfully
fragrant blossoms but requires attentive care.

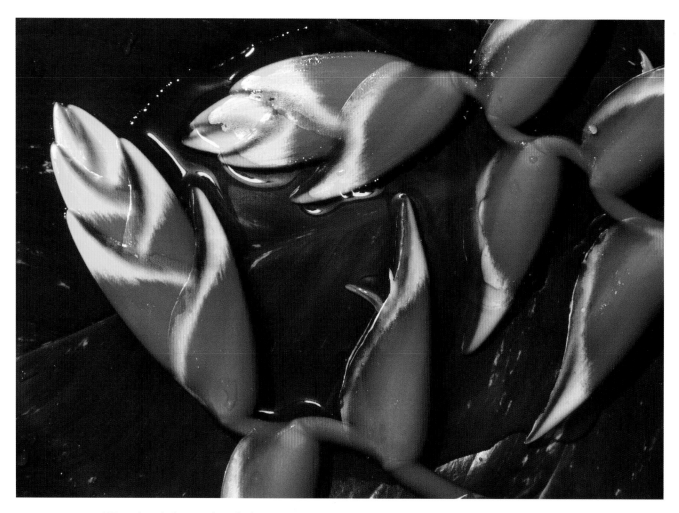

Hanging lobster claw heliconia, a native of South America and the Caribbean, is a popular choice for flower arrangements.

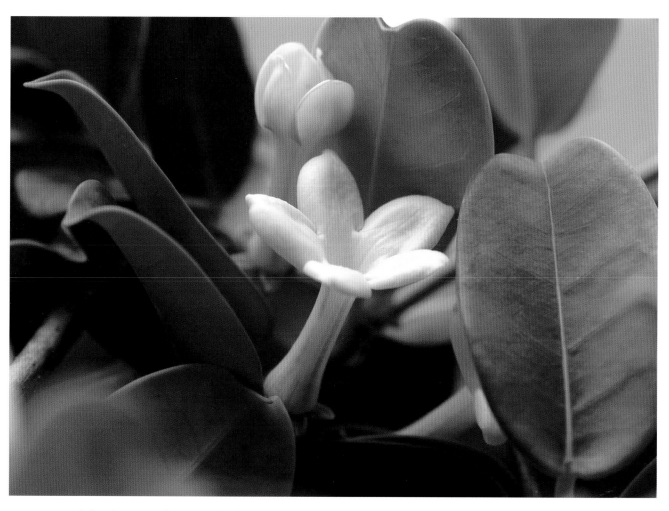

The fragrant flowers of stephanotis, a member of the milkweed family, is frequently chosen for bridal bouquets and also strung into leis.

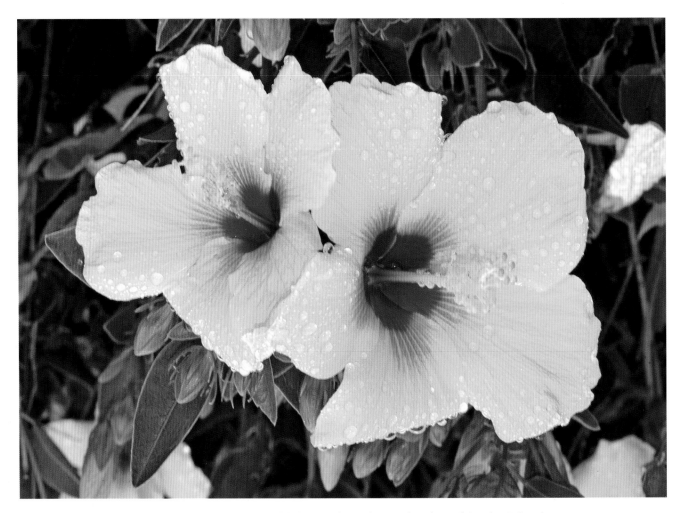

Hundreds of varieties of hibiscus have been developed in the Islands
by hybridizing both native and introduced species.

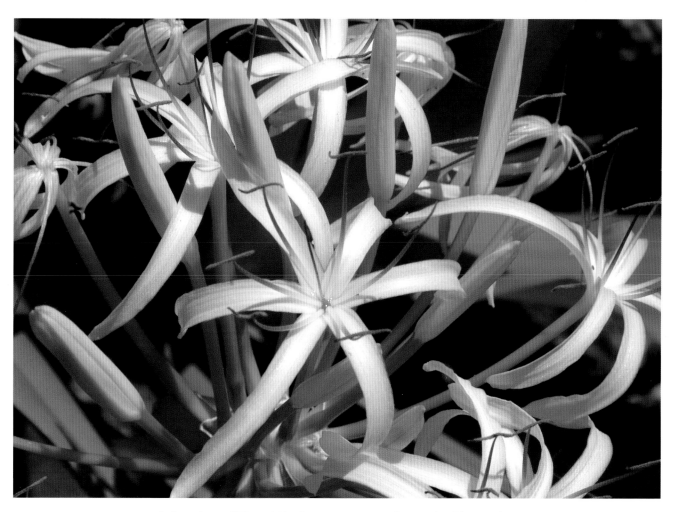

A favorite of Hawai'i's Queen Emma, the spider lily is often
grown in coastal sites throughout the Islands.

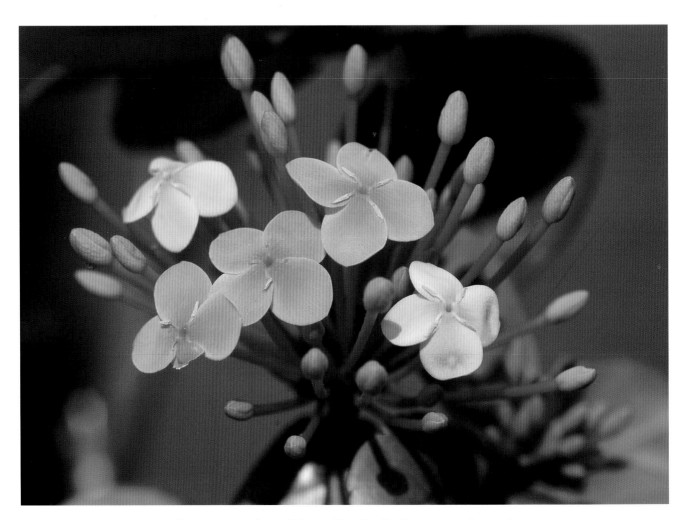

Ixora, a member of the coffee family, is commonly used
for landscaping and hedges in Hawai'i.

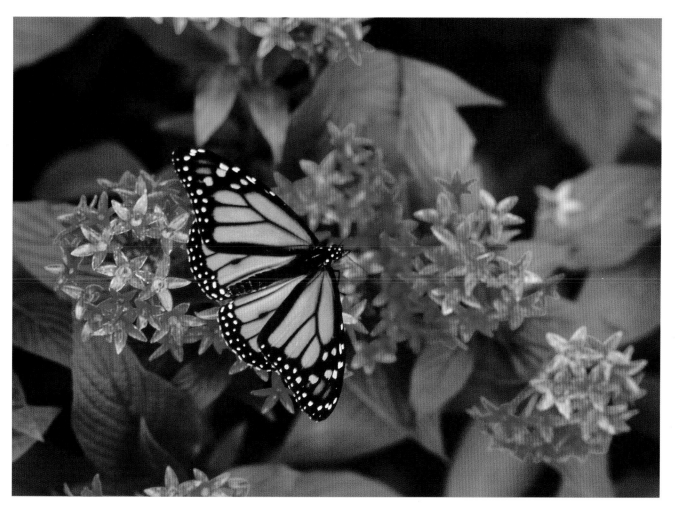

Pentas flowers are a popular source of nectar for monarch butterflies.

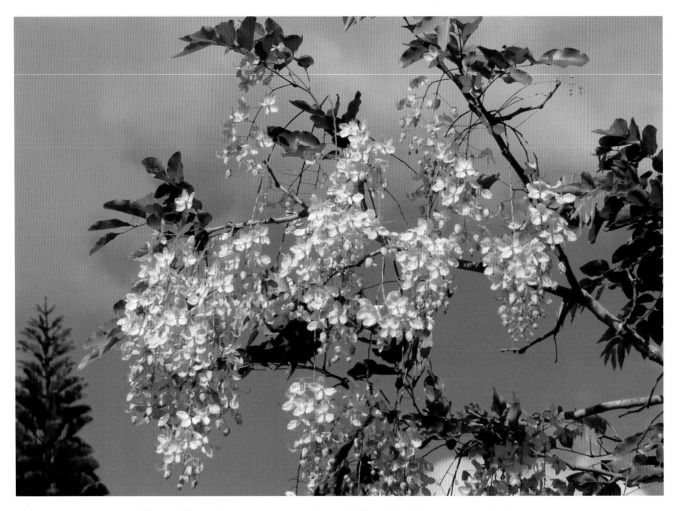

The golden shower tree, a native of the Himalayas, drops its leaves
before flowering from spring through summer.

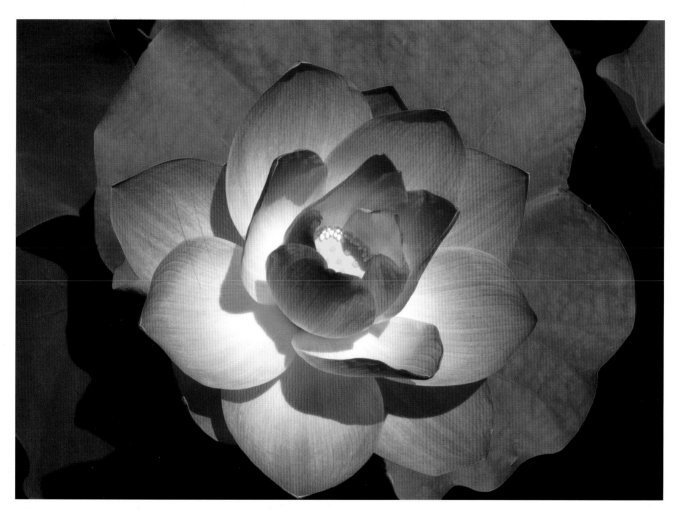

The "sacred lotus," symbolic of the Buddhist religion, produces elegant flowers and an edible root in its wetland habitat.

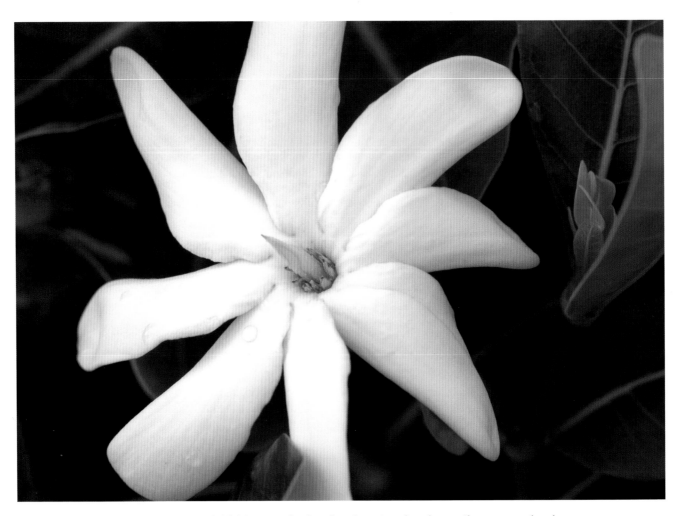

Also known as Tahitian gardenia, the tiare is a hardy, easily-grown shrub
with very fragrant flowers, sometimes strung into a lei.

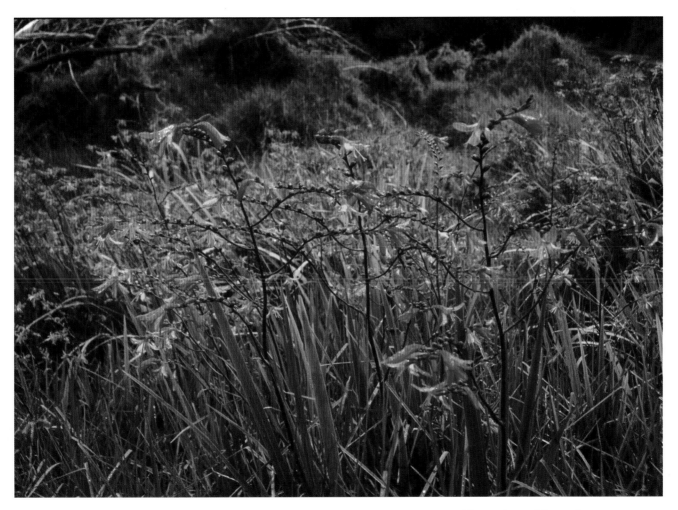

Montbretia is a cross between two species of iris. It grows readily in the wild, prefers a cool climate, and reproduces by means of small bulb-like corms.

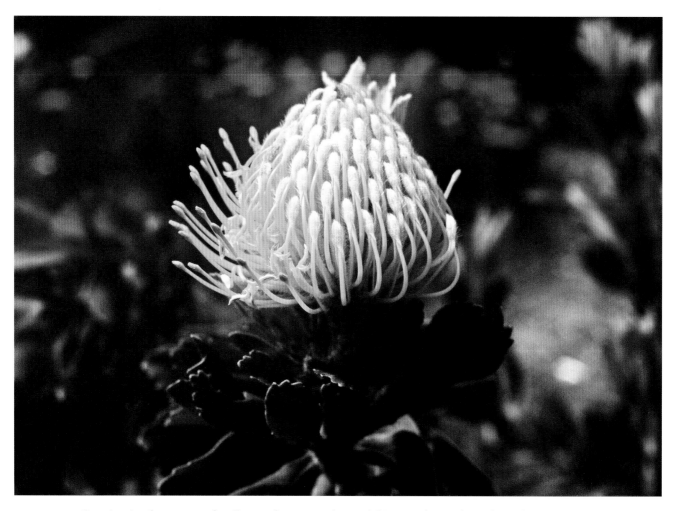

Species in the protea family are from southern Africa or Australia. These long-lasting flowers, like this pincushion variety, are very popular in floral displays.

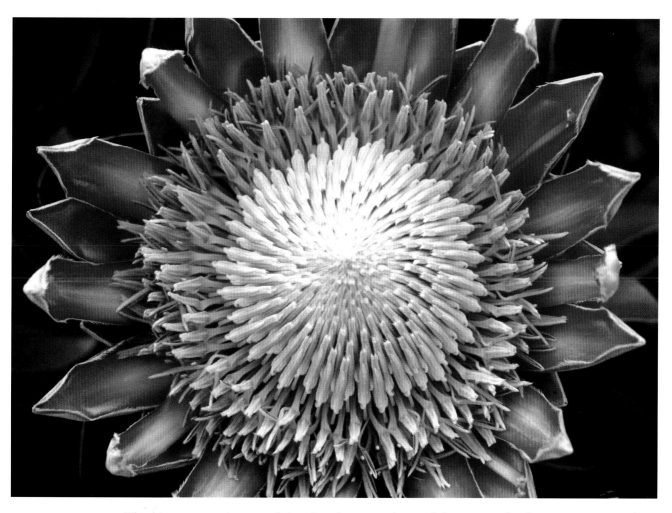

The king protea is one of the showiest members of the protea family;
the plants thrive in areas with warm days and cool nights.

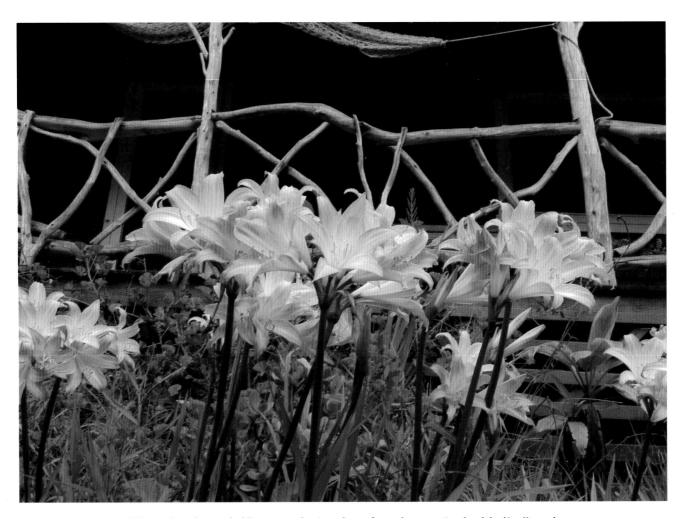

These bright pink lilies are gloriously referred to as "naked ladies" and "secret lilies," as the plant dies back with no leaves after flowering.

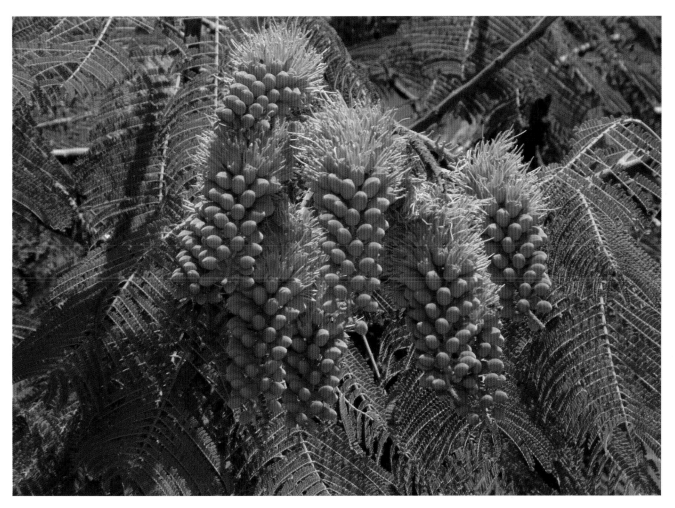

The orange buds of colvillea appear in October, but the tree looks quite barren
in winter and spring after its fern-like leaves drop off.

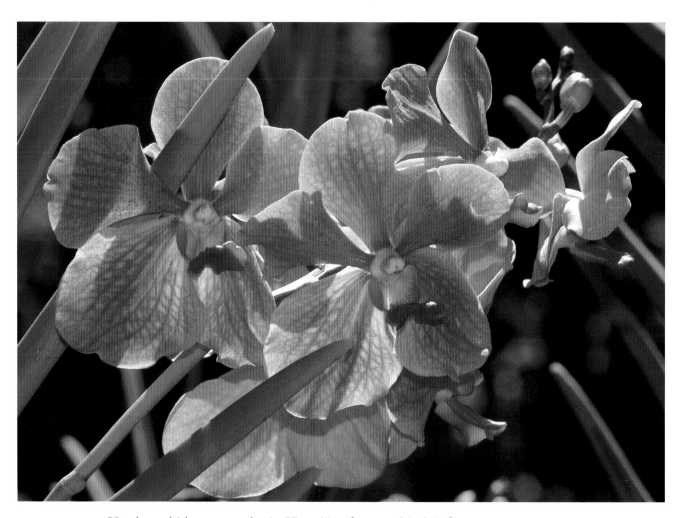

Vanda orchids are popular in Hawai'i, often used in lei, flower arrangements,
and perhaps as a decoration on the plate of a Waikīkī breakfast.

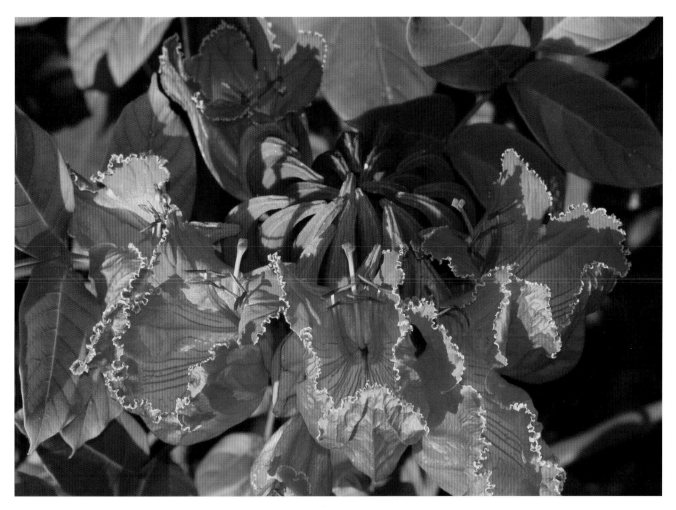

The colorful flowers of African tulip trees produce windblown seeds
that spread easily throughout the islands.

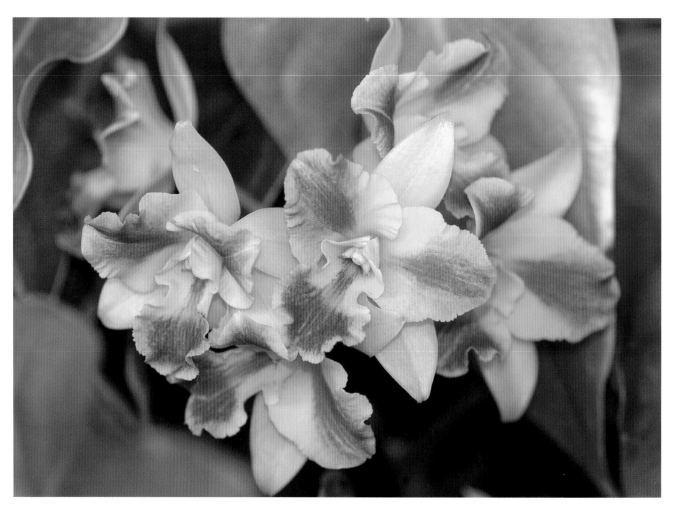

Most orchids grow best with warmth, moisture, and shade typical of their rain forest habitat.

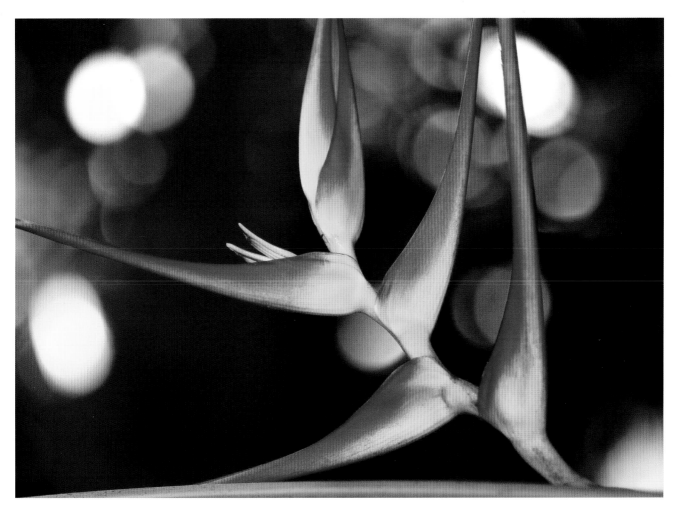

Heliconias display brightly-colored bracts covering clusters of smaller flowers.

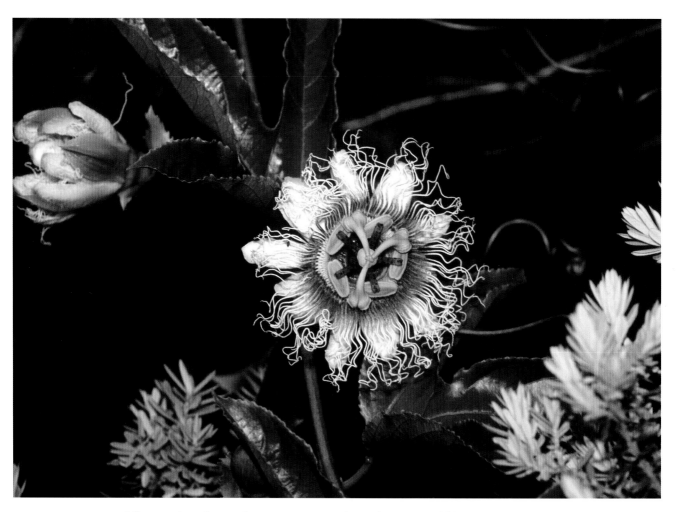

The passion flower becomes a tasty fruit, known as liliko'i in Hawai'i.

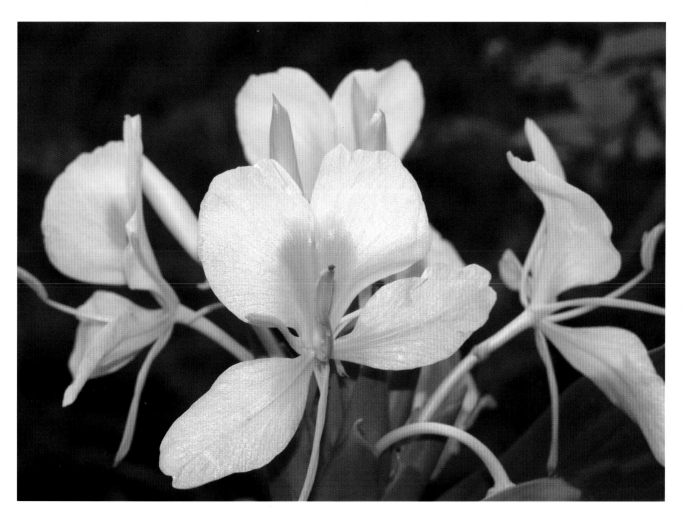

White ginger is among the most fragrant of Hawai'i's lei-making flowers.

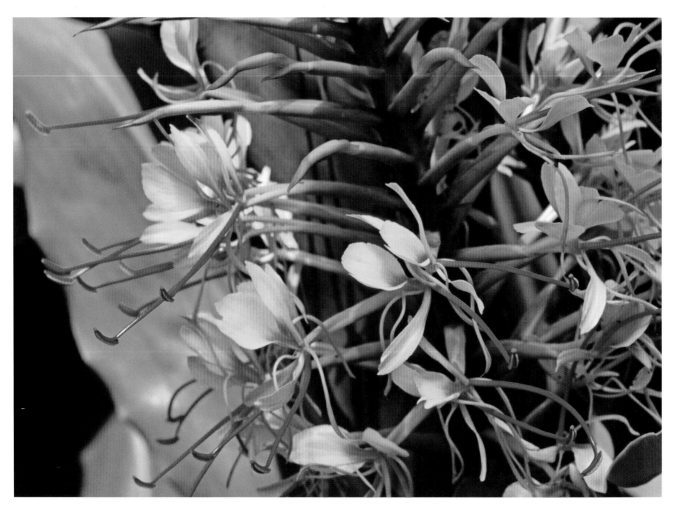

Although its flowers are attractive and very fragrant, kāhili ginger is an aggressive, invasive pest in the Islands' native forests.

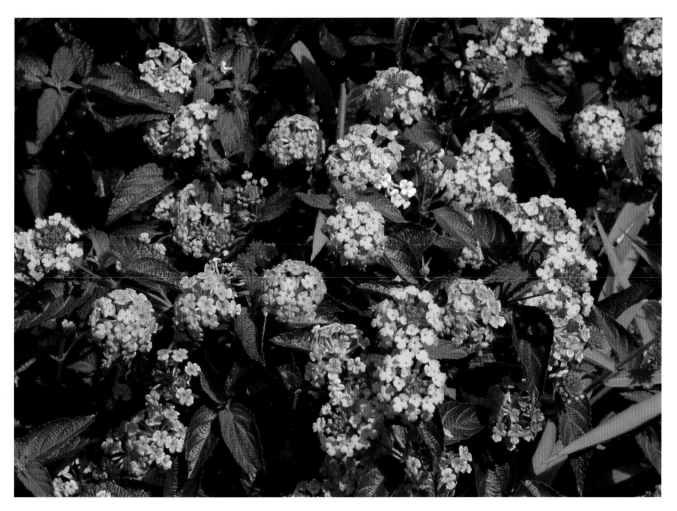

With its colorful compound flowers, lantana is a thorny pest to backcountry hikers in drier areas of the Islands.

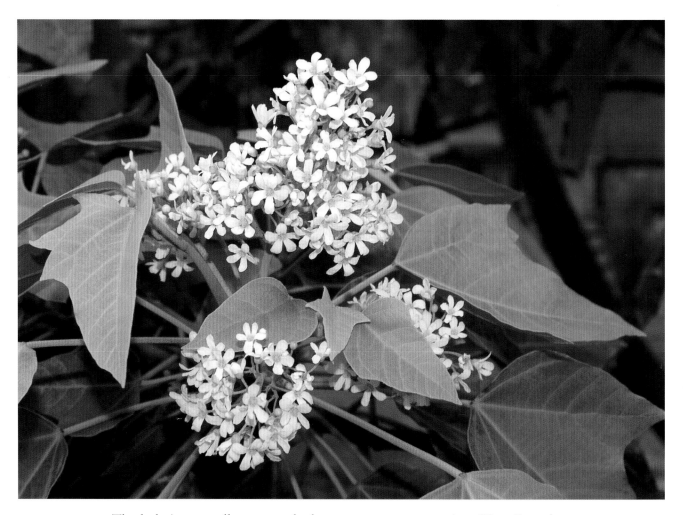

The kukui, or candlenut tree, had many uses among ancient Hawaiians, but today people are most familiar with the lei made from its seeds.

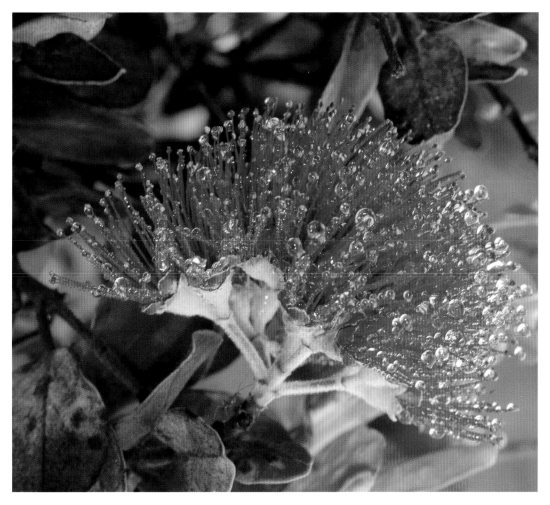

ʻŌhiʻa lehua is the dominant tree in Hawaiʻi's rain forests,
its flowers a source of nectar for native birds.

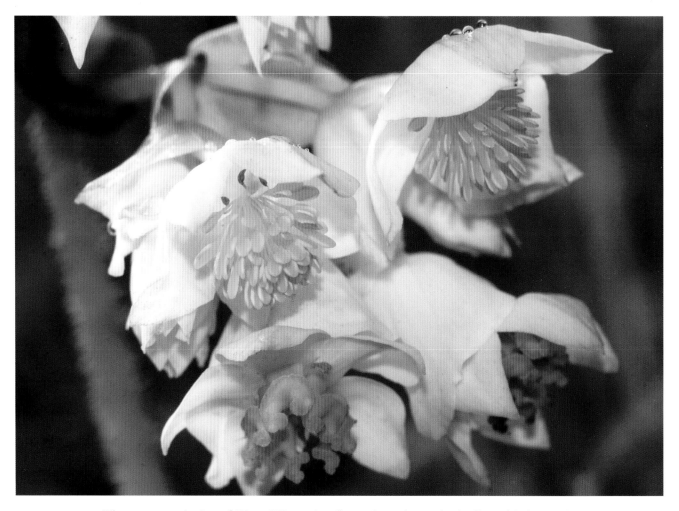

The great majority of Hawai'i's native flowering plants, including this begonia
(pua maka nui), are endemic to the Islands.

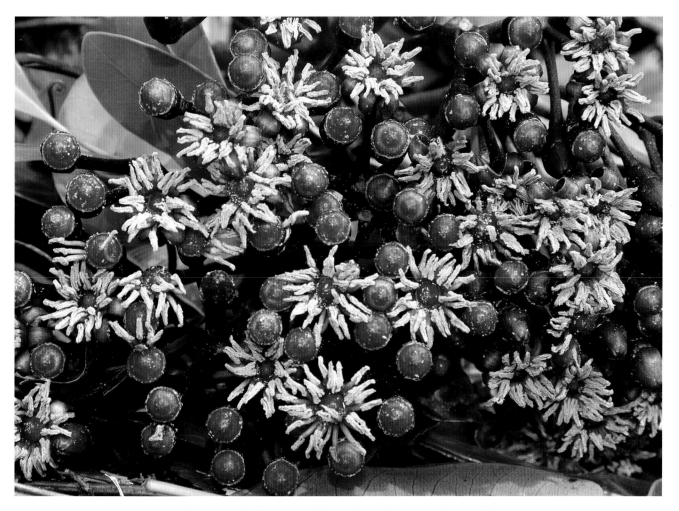

The unusual flowers of this ʻoheʻohe, a member of the
ginseng family, are pollinated by birds.

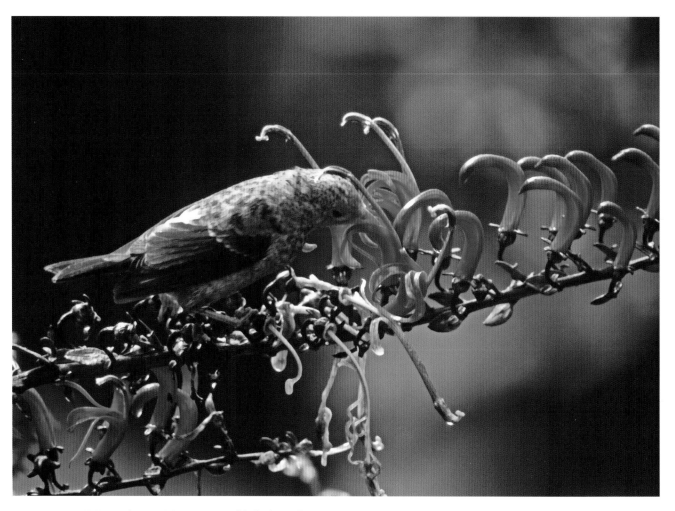

More than 100 species of lobelia relatives, including this koliʻi, have evolved in the Islands with curved flowers that provide nectar for native forest birds.

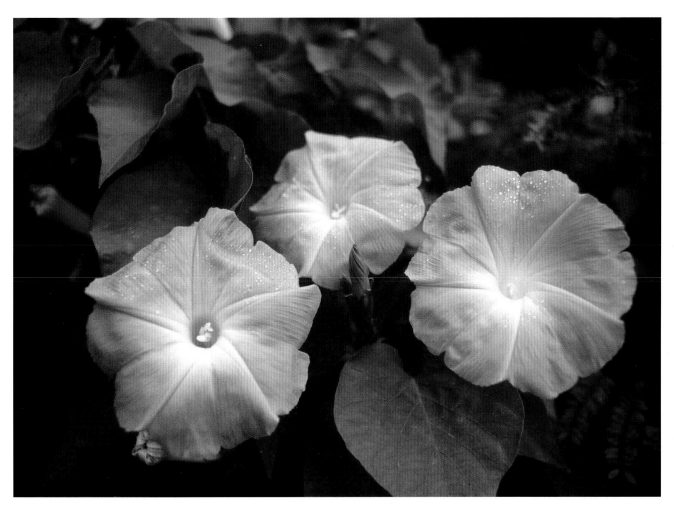

A bright star reaches from the center of these koali (morning glory) flowers, which will wilt at day's end.

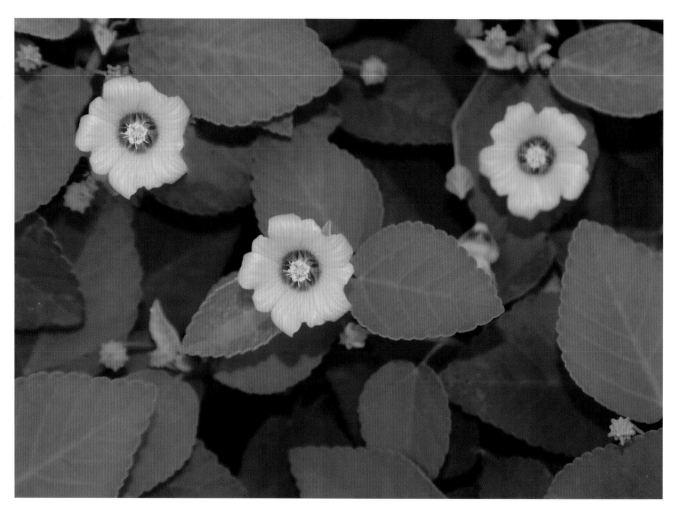

Flowers of the ʻilima plant, which grows along the coastline of many
Pacific islands, are strung into the island lei of Oʻahu.

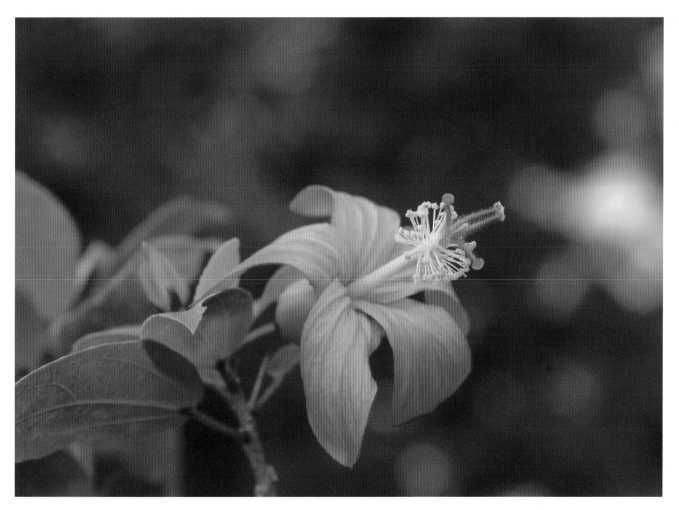

Most hibiscus flowers in island neighborhoods are hybrids, but there are several attractive native species such as this kokio 'ula from Kaua'i's Nā Pali coast.

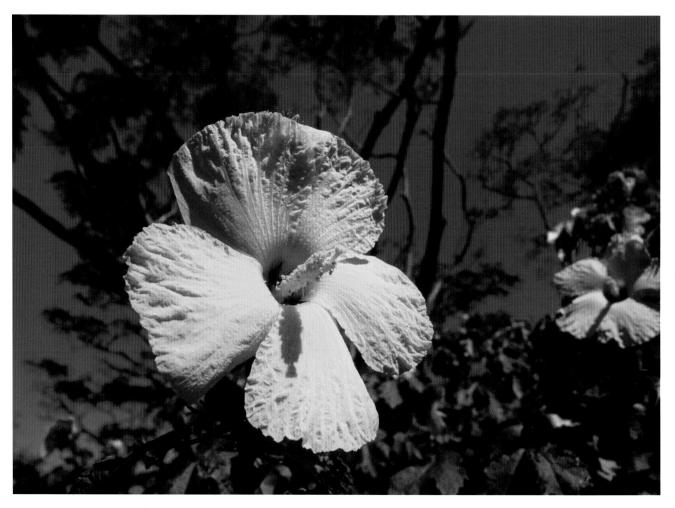

Hawai'i's state flower is a bright yellow hibiscus, ma'o hau hele, once found on all the main Islands but now quite rare or absent from its natural dryland habitat.